Play Virtual, Live Real

Live Real

Written by Mark Harrington

Salamander Street

First published in 2021 by Salamander Street Ltd.

(info@salamanderstreet.com)

Play Virtual, Live Real © Mark Harrington, 2021

All rights reserved.

ISBN: 9781913630720

Printed and bound in Great Britain

10 9 8 7 6 5 4 3 2 1

Contents

About the Breck Foundation

The Breck Foundation is a charity founded by Lorin LaFave after her 14-year old son, Breck Bednar, was groomed online and murdered.

Breck and his friends were groomed by an 18-year-old year old who ran an internet gaming server. They were told an elaborate web of lies to gain their trust. Despite many attempts to stop her son from contacting the predator, and to alert him to the fact that he was being groomed, Lorin was unable to prevent her son's murder in February 2014.

As a result of this tragedy, Lorin founded the Breck Foundation, determined that no other family should have to go through the same ordeal. The charity now delivers powerful presentations using Breck's story as an example; last year it reached more than 16,000 students, 2,000 parents and 4,000 safeguarding professionals.

Lorin believes that had her son seen the kind of talk that the Foundation now presents to schools, he would still be alive today.

The Foundation wants to ensure that no child is harmed through grooming and exploitation while enjoying their time on the internet. Prevention through education is essential.

The charity's 'play virtual, live real' motto reminds everyone to never meet alone in a private place with someone they have met only online.

For further information and resources, please visit **www.breckfoundation.org.**

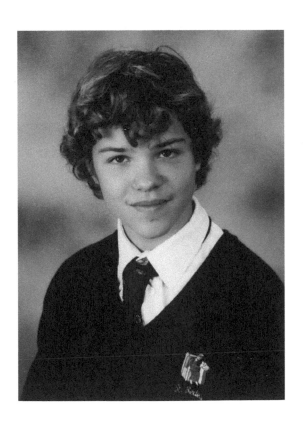

About the Author, Mark Harrington

Mark Harrington is a special needs teacher with more than 10 years' experience in SEN education. He specialises in Drama and English adaptions for special needs education. Mark is a trustee for the Breck Foundation, developing educational resources for the charity. For further projects that Mark is working on please see Instagram and Facebook @harrington_projects.

For

My Mum, Dad

&

brother, Adam.

Without your support, none of this would have
been possible

&

The Memory of Breck Bednar

Play Virtual, Live Real

First Performed at Manor Green College in
Crawley, West Sussex. A special needs college
for students with moderate to profound learn-
ing difficulties. The play was first performed of
30th November 2020, with the following cast:

BRECK Ethan Moran

LEWIS Toby Flude

MUM Eleanor Bell

MATT Toby Hall

EMMA Faith Waite

JAMIE Daniel Martin

CALL OPERATOR Samantha Morgan

Director: Mark Harrington

Co Director: Samantha Morgan

SCENE 1: DARKNESS.

Conversation in darkness.

POLICE OFFICER: Essex Police Emergency

LEWIS: Erm hello, I need police and a forensic team to my address.

POLICE OFFICER: What do you mean? What's happened?

LEWIS: My friend and I got into an altercation and I'm the only one who came out alive.

POLICE OFFICER: Are you telling me you've killed someone?

LEWIS: Yes, I am.

SCENE 2: INTRODUCTIONS

Sounds of game explosions, screams and gaming clicks and sounds.

Jamie, Matt, Emma and Breck are facing the front. The hooded figure of Lewis is facing away from the audience.

MATT: Come on guys, get them.

EMMA: Reload! Reload! Reload!

BRECK: I can't get to the switch!

JAMIE: Matt get them!

Each gamer freezes/continues gaming as the other talks about Breck.

BRECK: Hi, I'm Breck. I'm 14. I live with my family. I love gaming. When I grow up I want to be a gamer or design games.

JAMIE: Breck was by far the best gamer out of all of us. He helped me to get to level 50 on Shout of War! He was always a good friend.

MATT: Breck was like a brother to me. We would share everything. He'd help me with my homework, buy me

sweets on the way home from school. We'd even talk about what girls we fancied.

EMMA: He was always the cute one. I never told him I fancied him. I should have. I miss him.

Breck's Mum interrupts the scene and game play.

MUM: Breck, you need to come off there. Tea's nearly ready!

BRECK: Five more minutes Mum.

MUM: *(To the audience)* Breck was always on his computer blowing something up or on some quest. He always did his homework before going online though. He was always such a good boy. He helped me with his brother and sisters, did well at school. I never quite understood that computer world he played on but it made him happy. Everything changed when Lewis came online and into our lives.

SCENE 3: ENTER LEWIS.

A ping sound comes up

EMMA: I had been on Lewis's server for ages.

MATT: We all joined.

JAMIE: Me, Matt, Emma and Breck.

BRECK: Lewis's server was the quickest server I'd seen. There were no glitches and he knew loads of strategies and cheat codes for Zombie Hunter 5.

MATT: We all knew Lewis was a bit older than us; he said he was 17.

EMMA: We were only 14, but what's a couple of years?

JAMIE: Early on I thought everything sounded too good.

BRECK: Lewis was so cool.

LEWIS: *(not facing the audience)* Let me tell you about myself. I'm one of those young business whizz kids. I got money by letting people use my server. The US and UK governments are so impressed that I'm working with them. I made my first million by the time I was 16. I have houses in New York, Milan and London. Stick with me and I will lead you to easy street.

JAMIE: Can we see you in your profile picture? We can't really see you.

LEWIS: No… I need to keep my identity close because of my work in the government.

JAMIE: I swiftly deleted.

Jamie exits.

Knock at the door: Mum enters.

MUM: Breck, five minutes and we need to go to your Dad's. Who are you talking to?

BRECK: Matt, Emma, Jamie has just signed off and Lewis

MUM: Who's Lewis?

LEWIS: *(not facing the audience)* Hi Breck's Mum!

Cast except Mum freeze.

MUM: Lewis, he was charming, charismatic, he seemed to be wanting the best for these guys, he spoke to me, none of Breck's friends spoke to me when they were online. Lewis seemed to understand Breck and his online world better than I did.

Cast unfreezes.

MUM: Hi Lewis, five minutes Breck.

Mum exits.

BRECK: Be there in a second Mum.

SCENE 4: NEXT LEVEL

Lewis seems to have moved closer to Breck.

Game noises continue.

MATT: We got so far in our games with Lewis, it was amazing.

EMMA: I've never had so many weapons. I was like a human tank.

BRECK: I learnt so many new moves and skills from Lewis, I managed to build a new hard drive for my computer. Lewis sent me some parts for it too.

LEWIS: Anything to help a really good mate.

EMMA: I know the boys like to keep themselves to themselves but Lewis seemed to talk a lot to Breck.

MATT: We all knew they had private games and chats, but everyone does.

BRECK: I'm signing off in a bit.

LEWIS: I'll message you later.

EMMA: Little did we know what was going on in those messages.

Emma exits.

LEVEL 5: PRIVATE MESSAGES

Matt has turned round and it is just Lewis and Breck in conversation.

LEWIS: Thanks for letting me message you.

BRECK: No problem.

LEWIS: I message all the guys on my server but you are exceptionally good at gaming and coding. I'm well impressed.

BRECK: Cheers, I wish I knew more.

LEWIS: I have contacts at Microsoft and Apple, I'll put in a good word for you, they're always on the lookout for new talent.

BRECK: Really? Would you?

LEWIS: Sure… Breck I need to tell you something.

BRECK: Sure anything.

LEWIS: So, I was talking to Emma, and she doesn't like you, she said you're an idiot.

BRECK: Really? I thought she was my friend.

LEWIS: I know but some people are two-faced. I'd never lie to you.

Blackout

SCENE 6: CHANGES

Only Matt, Breck and Lewis are on stage.

MATT: We would game for hours and chat about tactics.

BRECK: Get that sniper up there Lewis

LEWIS: Got it.

MATT: But away from the gaming Breck changed.

Both boys come away from the gaming to the front of the stage. Lewis is lurking in the back. Breck is on his phone.

MATT: Breck did you get that English homework done? Can I copy?

BRECK: Nah I was busy. I was coding a new game with Lewis.

MATT: But that's for Mr. Webb, you know he's mental. You do know that gaming stuff with Lewis is just a game?

BRECK: No! He can make stuff happen. He knows people.

MATT: He says that, but we've never really seen him.

BRECK: I have, he put his camera on.

MATT: I bet it was all dark and gloomy like his profile pic.

BRECK: No! Just shut up, you're just jealous.

MATT: Jealous of someone you've never met? He's probably lying.

BRECK: Just shut up! You know nothing! I'm going places and you're just jealous.

Breck walks off. James faces the audience.

MATT: Me and Breck had never fallen out before. This hurt. But who could I tell that I thought things were wrong?

Fade out.

SCENE 7: EVERYTHING HAS CHANGED.

Breck and Lewis side by side. Mum is at the stage edge.

MUM: Things had changed. No one seemed to come round anymore to see Breck and he hardly went out. Everything we spoke about was Lewis or computers…. Or Lewis.

Mum opens an envelope. She's stunned by what she sees. She storms to Breck's room and knocks on the door.

MUM: What is this?

Breck copies every movement that Lewis makes. Lewis' jaw seems to move at the same time.

BRECK: Oh that!

MUM: What do you mean 'Oh that!' Your school report, you are an A star student and this has F's and cause for concern!

BRECK: Who cares!

MUM: You should care! Your future depends on these grades.

BRECK: I don't need school. I'm leaving school. I'm going to work with Lewis developing computer programs for games and the government. I don't need school.

MUM: You are joking, right?

Lewis answers but Breck mouth moves at same time.

LEWIS: You bet Mummy dearest. I don't need school! I don't need friends! I don't need you!

MUM: That's it! Give me your phone and unplug that computer.

BRECK: No! I need it for my work.

MUM: I will not accept this behavior in my house

Mum pulls out a cable.

BRECK: I hate you!

Breck screams in a rage and pushes Mum to the floor.

Mum stares at her son. Breck gets his phone and throws the laptop on the floor in front of her. He slumps in chair. Mum gets his things and walks out with them.

When he thinks Mum has gone, he walks over to the side of the stage and pulls out another phone.

BRECK: Sorry you had to hear that.

LEWIS: It's alright, parents can be tough but we need her on our side. We will need to sweeten her up. Let's play nice.

Scene fades

SCENE 8: LAST LEVEL

MUM: After that things seemed to get better. Breck didn't have his phone or computer and he spent time with us. It was like having the old Breck back.

Breck texting Lewis.

BRECK: She doesn't have a clue.

LEWIS: Good… Breck I've got something to tell you.

BRECK: Is everything alright, Lewis?

LEWIS: No man… I'm dying!

BRECK: What?

LEWIS: I haven't got long left and I don't have time to explain. Breck, you are like family to me and I don't have anyone else who has the knowledge you have or that I trust.

BRECK: What do you want me to do?

LEWIS: I want you to run my company… all my money, homes, businesses would be yours. I've sorted out all the paper work but I need you to sign some papers in person.

BRECK: Don't I have to be 18 or something? Shouldn't my Mum know about it?

LEWIS: No! You have seen how she behaved when you tried to discuss things reasonably with her.

BRECK: True.

LEWIS: Don't tell her. Here is what we are going to do. First….

Fades out…

SCENE 9: GAME OVER BRECK

Lewis is gone.

Leaving Breck on stage alone.

James, Emma, Jamie and Mum take 4 corners of the stage.

MATT: That day Breck phoned his Dad.

BRECK: Hi Dad. Is it okay if I don't come today? I've got lots of homework to do. Cheers.

EMMA: He went to his Mum.

BRECK: Mum, I'm going to pop to the cinema with Matt before I go round to Dad's.

MUM: That's nice, I've not seen him round for a while. It will be nice for you two to catch up. Look, here's some money for some popcorn.

BRECK: I love you, Mum.

MUM: I love you, too.

JAMIE: He went and checked his phone.

BRECK: Is everything ready?

LEWIS: Yeah, I have paid for a taxi to pick you up from your house and bring you here.

BRECK: Awesome. Can't wait to finally meet you in person.

LEWIS: You too. See you soon

BRECK: Laterz

Breck acts out the following.

MUM: He left the house and got in a taxi.

MATT: Breck was in the car for half an hour.

EMMA: Breck didn't know where he was going to.

JAMIE: Breck arrived at Lewis's.

MUM: It wasn't a mansion in London.

MATT: But an apartment block of flats.

EMMA: In a rough area that Breck didn't know.

JAMIE: He found Lewis's flat door and knocked.

Knocks.

LEWIS: Breck

BRECK: Lewis

LEWIS: Come in.

MUM: Breck went in … But he never came out.

Sound effect door slam. Game over and power down.

SCENE 10: A WARNING

Darkness Voice-over.

POLICE OFFICER: Essex Police Emergency

LEWIS: Erm Hello, I need police and a forensic team to my address.

POLICE OFFICER: What do you mean? What's happened?

LEWIS: My friend and I got into an altercation and I'm the only one who came out alive.

POLICE OFFICER: Are you telling me you've killed someone?

LEWIS: Yes

Lights come up.

MUM: Lewis murdered Breck…Breck died. Breck was just 14.

MATT: The signs were there… if only we had tried to speak to people about what was going on

EMMA: There are many good things on the internet but there are some people out there who want to hurt you.

JAMIE: When using online games, chat rooms, social media platforms, remember

LEWIS: Breck

BRECK: Be aware and believe

EMMA: Be aware of the real and increasing dangers today's children may face online. Believe that there are people

who use the internet to groom, abuse and exploit young people.

BRECK: Report it

MATT: Report any concerns immediately to school, police, Childline, NSPCC or CEOP. Even small pieces of information when put together can make up the bigger picture of what may be happening to a child online.

BRECK: Educate and empower

JAMIE: Educate others on the signs of grooming and exploitation. Be empowered to act on concerns.

BRECK: Communicate

LEWIS: Encourage and support young people to communicate concerns about themselves or how their peers are behaving online. Support others by sharing Breck's story within your community

BRECK: Know the signs and keep safe.

MUM: Know the signs of grooming and exploitation. Keeping safe online must be everyone's priority!

ALL CAST: Play Virtual, Live Real.

BRECK: Remember Breck.

Fade to black.

The Breck Principles

The Breck Foundation is raising awareness for playing safe whilst using the internet. Keep safe by following these simple principles that we have created using Breck's name.

Be aware & believe

Be aware of the real and increasing dangers today's children may face online. Believe that there are people who use the internet to groom, abuse and exploit young people.

Report it

Report any concerns immediately to school, police, Childline, NSPCC or CEOP. Even small pieces of information when put together can make up the bigger picture of what may be happening to a child online.

Educate & Empower

Educate others on the signs of grooming and exploitation. Be empowered to act on concerns.

Communicate

Encourage and support young people to communicate concerns about themselves or how their peers are behaving online. Support others by sharing these principles within your community.

Know the signs & Keep safe

Know the signs of grooming and exploitation. Keeping safe online must be everyone's priority!

Play Virtual, Live Real Scheme of Work

SUBJECT: PHSE/English/Drama/ICT/ Assembly or Class Presentation

TOPIC/UNIT: ' Play Virtual, Live Real' Play: Online Grooming and Keeping Safe

NO. OF LESSONS: 6

About the unit:

' Play Virtual, Live Real' is aimed for learners with a cognitive age of 12+ years old.

The aim of this scheme of work is to introduce the story of Breck Bednar and begin instilling an understanding of online safety and online grooming. It is designed for SEN students, but equally could be aimed at lower ability groups. The play is centred around six or seven characters.

Students will study:

- The story of Breck Bednar
- Who to talk to talk about worries online
- What is grooming?
- Feelings involved in grooming
- Presenting and sharing the message of the Breck Foundation

Resources can be used to support and consolidate learning. Please change story writing wherever needed to a size, font or symbol that best supports your students.

The play can be used as a tool to prepare for an assembly, or share information on internet and computing safety with another class.

If, during the process of studying this text, a student asks to speak to staff or divulges any safeguarding concerns, please follow your facility's safeguarding procedures.

The Breck Foundation is continually developing resources. We are currently developing music that will be available to support students with emotional literacy enabling communication of the story. These pieces of music could be used during or at the end of your storytelling or presentations. They could be sung and signed by the groups.

Please share any work you create with the Breck Foundation on social media using @ breckfoundation.

For further information and resources please go to **www.breckfoundation.org**.

Warning to educators:

Students will be introduced to a simple outline of the events surrounding the death of Breck Bednar.

Please inform parents and guardians that their child will be studying online safety with a focus on the Breck Bednar story. This is important due to the wide range of videos and interviews that are available online and across social media. If you feel it is appropriate, you may want to arrange a meeting with parents to discuss how they can support their children's learning during this scheme of work. Please see Appendix 1 for an example of a guide letter to parents and guardians.

Learning intentions	Teaching activities	Differentiation/ Points to note	Resources
To understand the story of 'Play Virtual, Live Real' To understand that Breck was a real person	• Introduce that you are going to be studying the play 'Play Real. Live Real.' • Ask if anyone knows anything about Breck. • Study the cover of the book. What could the story be about? What clues are there? • Read ' Play Virtual, Live Real'. • Give time for the story to sink in offer some time of reflection. You could put a piece of music on.	1. Please adapt the writing in the books to the size or symbol that is suitable to your class group 2. When discussing the fact that this play is based on true events you may want to use Appendix 2: Image of Breck 3. Some students may need to stop the lesson and have some further time to process. Please give them extra time and space	1. ' Play Virtual, Live Real' play 2. Appendix 1 Letter for Parents 3. http://www. breckfoundation. org/brecks-last-game-our-work 4. Appendix 2: Image of Breck

BRECK FOUNDATION

Learning intentions	Teaching activities	Differentiation/ Points to note	Resources
	• Ask students to discuss their initial reactions. How do they feel?	4. Choose wording of computer/internet carefully. Students may think that groomers only work through the internet if you use only the phrase internet. Try using computer and internet together.	
	• Explain to the students that this play is based on true events.		
	• If you have parental permission, show video. 'Breck's Last Game'		
	• Give students time to reflect and discuss their feelings after viewing the video.		
	• Explain to the students the mother in the video is Breck's mum who has set up a charity to stop this happening to anyone else.		

BRECK FOUNDATION

Learning intentions	Teaching activities	Differentiation/ Points to note	Resources
	• Explain to the students that we are studying the play to help prevent this happening to anyone else. • Explain that if someone had spoken out maybe this tragedy would not have happened. • Ask students to think about who they feel they would like to portray in the play. • Before leaving remind students that this is a rare thing to happen. We are trying to prevent and support rather than scare.		

BRECK FOUNDATION

Learning intentions	Teaching activities	Differentiation/ Points to note	Resources
To create a play from the story ' Play Virtual, Live Real' To develop emotional understanding	• Begin by reminding students they are going to share what they have learnt with someone else, a class or the school. • Pretend that you have forgotten what happens in the play. Ask students to recall what happened in the play. • Get students in their groups to begin thinking who will play whom in the play. • Get the students to read the play as their characters (if anyone needs to swap characters this would be the time to do it).	• Please adapt the writing in the books to the size or symbol that is suitable to your class group • Lower ability students could have the feelings words in front of them.	• ' Play Virtual, Live Real' play • Any props you are using to support the story telling (game controllers, laptops) • Appendix 3: Emotional Journey • Appendix 4: Feelings (if needed) • Pen • Glue (if needed) • Scissors (if needed)

BRECK FOUNDATION

Learning intentions	Teaching activities	Differentiation/ Points to note	Resources
	• Give the students Appendix 3: Emotional Journey. • Students are to look at the emotional journey their character goes on throughout the play. • Students should think how the character changes from beginning to end of their time on stage. • Students should then look at the other characters, and how they might feel throughout the play.		

BRECK FOUNDATION

28

Learning intentions	Teaching activities	Differentiation/ Points to note	Resources
	• Once students have completed this, get students to find a space in the room. Get them to do a freeze frame of their character as you say 'beginning' 'middle' and 'end'. • Emphasise facial expressions and body -to portray this. • Give students time now to rehearse thinking about these gestures and facial expressions. • Where time permits show each other's plays.		

BRECK FOUNDATION

29

Learning intentions	Teaching activities	Differentiation/ Points to note	Resources
	• To finish discuss with your class how Lewis' feelings took control and ruined many lives. If Breck's friends had spoken to someone about what they thought was going on, the story could be quite different. • Remind students that if they are worried or scared whether that be online or face to face with someone. They must tell a trusted adult. People will listen and help.		BRECK FOUNDATION

Learning intentions	Teaching activities	Differentiation/ Points to note	Resources
To understand the story of Breck To develop presentation skills To understand about grooming	• Remind students that this story is truth and should be taken seriously. • Ask students what they understand to be a 'groomer'. • On the floor in groups, give packs of images of different people ranging in age, sex and race. Ask students to select which one they think is the most likely to be a groomer.	• Please adapt the writing in the books to the size or symbol that is suitable to your class group • You may want to put Lewis's picture in the mix of possible groomers • Appendix 5 could be done in groups of 4 and each student takes a tool to look for and share with their group.	• Play ' Play Virtual, Live Real.' • Selection of pictures ranging in age, sex and race. • Appendix 5: 'The Groomer's Toolkit

BRECK FOUNDATION

Learning intentions	Teaching activities	Differentiation/ Points to note	Resources
	• The answer is potentially any of them. If any of them are doing something to isolate, create a false reality, control, or manipulate another person, in can be seen in the eyes of the law as grooming. • Remind students that Lewis was only 18 when he was arrested.		

BRECK FOUNDATION

Learning intentions	Teaching activities	Differentiation/ Points to note	Resources
	• Give students Appendix 5: 'The Groomer's Toolkit'. Explain to students that these are the fundamental things that a groomer will do to someone to make them do what they want.		
	• Get students to go through the play and see where Lewis was using the toolkit to get to Breck.		
	• Make sure students understand the words that have been used.		

BRECK FOUNDATION

Learning intentions	Teaching activities	Differentiation/ Points to note	Resources
	• When the group come together share ideas. • To extend the task ask students to think of other things a groomer could do or say to get to someone. • With what students have studied about the toolkit, get them to think how they could show this on stage. This could be through stage positions, puppetry and Lewis's location throughout the play.		

BRECK FOUNDATION

Learning intentions	Teaching activities	Differentiation/ Points to note	Resources
	• At the end of the lesson, remind students that not everyone who tries to help and care for us is a groomer. Most people want what is best for us. • Remind students that if they feel they are being made to do something they do not like or feel, or they are being hurt by someone they must tell an adult. Equally if they are worried about a friend or family member they must tell a trusted adult.		

Learning intentions	Teaching activities	Differentiation/ Points to note	Resources
To create a play from the story ' Play Virtual, Live Real' To recall the Groomer's Toolkit and how it was used against Breck To realise the warning signs if you or a friend are being groomed	• Begin by reminding students they are going to share what they have learnt with someone, a class, or the school – in the next week. • Ask students to recall the 'Groomer's Toolkit' and what that looked like in the story of Breck. • Explain to students that there were many warning signs that things were not quite as they seemed with Breck and Lewis's friendship.	• Please adapt the writing in the books to the size or symbol that is suitable to your class group • When using clips decide what is appropriate for your group.	• Play ' Play Virtual, Live Real.' • Any props you are using to support the story telling • Appendix 6: Warning, Groomer Ahead.

BRECK FOUNDATION

Learning intentions	Teaching activities	Differentiation/ Points to note	Resources
	• Give student Appendix 6: 'Warning Groomer Ahead'. Explain to students that you are going to watch some clips and you want them to listen and try and recognise any signs that were recognised by friends and family. • Depending on time, use the short film Breck's Last Game, This Morning Interview with Lorin La Fave, Channel 4 Interview with Lorin La Fave.		• Short Film – Breck's Last Game http://www.breckfoundation.org/brecks-last-game-our-work Clip: This Morning: Lorin La Fave https://youtu.be/fXuol4cyihE Clip: Channel 4 News Interview with Lorin La Fave https://www.youtube.com/watch?v=6dXkFqt6SVo

Learning intentions	Teaching activities	Differentiation/ Points to note	Resources
	• After watching the clips discuss with the students the signs that were recognised by others. • Answers could include: changes in Breck, control, lack of profile picture, obsessive behaviour etc. • Ask students to think in their performances how these warning signs are dismissed. If someone had taken a second to speak to a trusted adult, it could led to a different outcome.		

BRECK FOUNDATION

Learning intentions	Teaching activities	Differentiation/ Points to note	Resources
	• From what students have learnt today think of the feelings that the people involved may have felt when these warning signs were being displayed. Think how these emotions can be played out in their acting. • At the end of the lesson, discuss with the students that it is good to talk about our feelings and that it is good to share how we feel. Remind students if they have worries or fears they should discuss with a trusted adult.		BRECK FOUNDATION

Learning intentions	Teaching activities	Differentiation/ Points to note	Resources
To consolidate learning To create a play of 'Play Virtual, Live Real'	• Explain to students that within the next week we will be performing their work to another group. • Try to recall all the issues that students have come across so far including the tool-kit, recognising the signs, the feelings involved. • Ask students, to create/ write an alternative version of the play, where the friends speak to people who could help when they realise the signs of what is happening to Breck.	• Edit the play in whatever way suits your students. • When creating a new version of the play, students could either write the scene or try to act it out.	• Play 'Play Virtual, Live Real.'

BRECK FOUNDATION

Learning intentions	Teaching activities	Differentiation/ Points to note	Resources
	• Students to share their ideas with each other. • Give feedback. • Give students time to rehearse their versions of the play. • Remind students that recognising the signs and sharing with someone could have changed many people's lives. • Remember most people are out there to help us not harm us.		

BRECK FOUNDATION

Learning intentions	Teaching activities	Differentiation/ Points to note	Resources
To teach others the story of Breck To consolidate learning To share the Breck Foundation message	• At this point students should have presented their work to someone, a class or school. • Firstly, congratulate students on doing a good job. • Share videos or images from their presentation with the students. • Using Appendix 7: Storyboard, use photos of the student's presentation. Get students to re-write the story of what happened to Breck.	• Please adapt the writing in the books to the size or symbol that is suitable to your class group • Appendix 7 can also be drawn by the students • If Appendix 7 is not suitable, you may want to create a poster for the Breck Foundation or a photo montage of the students work.	• Permission for students images to be used on social media • Camera • Appendix 7:Storyboard • Images or video of the students presentations • Glue • Scissors

BRECK FOUNDATION

Learning intentions	Teaching activities	Differentiation/ Points to note	Resources
	• Once work is complete, discuss with students that you are going to send their work to the Breck Foundation @breckfoundation (on social media) to show that the students have taught others about the Breck story. • After this, evaluate with students all they have learnt over the previous weeks.		

Learning intentions	Teaching activities	Differentiation/ Points to note	Resources
	• Finally, remind the students that what happened to Breck is extremely rare; however, we are trying to keep as many people safe as possible. Remind them that this was a real story and that if any of the students have any worries, they must talk to a trusted adult.		BRECK FOUNDATION

Identified opportunities for ICT: Any or all parts of this scheme of work can be transferred to computer. Please feel free to adapt and change to fit the needs of your students.

Helping the Breck Foundation: Please share with us any work, presentations, assemblies or; displays that students create. Please make sure that you have all necessary permissions before sending anything to us. Share with us on social media @breckfoundation or email one of the team. We are developing our resources continually and like to see what ideas you come up with when sharing the story. Please look on our website for further information, including videos, music and ways to support the charity further: **www.breckfoundation.org**

Appendix 1

Letter to Parents and guardians regarding the intoduction to 'Play Virtual, Live Real'

Dear Parent or Guardian

Over the next six weeks your child will be studying online safety and online grooming. We will be using the play ' Play Virtual, Live Real' as our educational focus.

This book will introduce students to online grooming and issues surrounding internet safety. It is based on the true story of Breck Bednar. Breck was a 14-year-old boy who was groomed online whilst gaming with a person Breck believed was his friend. Breck was lured to the 18-year-old predator's flat and murdered.

We will also be watching the short film 'Breck's Last Game'. This is to support students with their studies. It is important that you view this video before the lesson so that you can support your child with the emotions if necessary: www.breckfoundation.org/brecks-last-game-our-work.

Over the coming weeks your child may have further questions and may want to discuss what happened to Breck. There are lots of interviews and information online and on social media about Breck, and you may want to filter what is seen and read by your child.

We recommend that the play 'Play Virtual, Live Real' is a good place to start when discussing this topic. A storybook edition is available to order online and and you can find out more information about Breck and the work of the charity, the Breck Foundation, at www.breckfoundation.org.

I will be arranging a meeting with parents and guardians on _____ to discuss this scheme of work. Please let me know if you are able to attend or have any further questions.

We thank you for your continued support.

Regards

Appendix 2

Picture of the real Breck Bednar in Year 9

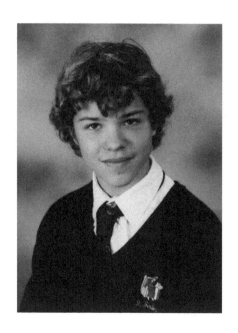

Appendix 3

Emotional Journey

Breck's Mum (Lorin)	Lewis
Beginning	Beginning
Middle	Middle
End	End
Breck	Choose one of Breck's friends
Beginning	Beginning
Middle	Middle
End	End

Appendix 4

Feelings

Sad	Angry	Confused
Lost	Happy	Lonely
Controlling	Mean	Excited
Trusted	Awful	Manipulative
Powerful	Scared	Manipulated

Appendix 5

The Groomer's Toolkit

Isolation	False Reality
Control	Manipulation

Appendix 6

Warning, Groomer Ahead

Appendix 7

Storyboard

CPSIA information can be obtained
at www.ICGtesting.com
Printed in the USA
JSHW012332010621
15453JS00010B/54